Wisdom With
Understanding
is Better
Than Rubies

Lurine Karon Greenberg
Fine Arts Collection

STEVE WOLFE

STEVE WOLFE

ON PAPER

Carter E. Foster | **Franklin Sirmans**

Whitney Museum of American Art, New York

The Menil Collection, Houston

Distributed by Yale University Press, New Haven and London

Contents

Directors' Foreword

This exhibition and catalogue offer the first major in-depth look at artist Steve Wolfe's works on paper, some of which are purely drawn but many of which combine aspects of drawing, painting, collage, and printmaking. Made during the course of several decades, Wolfe's trompe-l'oeil still lifes of books, vinyl records, and book crates investigate the intersections among material culture, intellectual history, and personal and collective memory.

As Carter E. Foster writes in his essay for this catalogue, seventeenth-century Dutch and nineteenth-century American trompe-l'oeil still lifes are relevant precedents for the consideration of Wolfe's art. But what does it mean to make trompe-l'oeil works today after the invention of photography, in the midst of the computer age and the era of virtual reality when any material, color, surface, or volume can be recreated with infinitesimal detail and verisimilitude? What also does it mean to produce trompe-l'oeil works post–Jean Baudrillard's notion of the simulacra and in the wake of an outpouring of "appropriation art" beginning in the 1970s when artists intentionally copied existing images not to be viewed as copies but as "originals" in their own right?

Wolfe's art, while in the grand tradition of trompe-l'oeil painting, came to the fore in the midst of this crisis of the real — a questioning not only of what we experience but of experience itself. While the viewer is able to enjoy Wolfe's delectable drawings and painted objects for the way in which they painstakingly imitate surfaces and re-present book covers, there is more — or perhaps one might say less — to them than that. In this age of screen culture, the real seems to be less real and lacking in substance. Wolfe's works are projections of his ideas onto the "screen" of paper or a wooden support. As Roland Barthes wrote, "realism consists not in copying the real but in copying a (depicted) copy.... Through secondary mimesis [realism] copies what is already a copy."[1] The notion of a trompe-l'oeil object produced through the physical agency of the artist's touch using pigment continues to be compelling. His works have a visceral character and a felt presence that is very appealing, almost nostalgic, at a time when the manufacturing of most of our material culture is beyond our comprehension. Drawing and painting — particularly of recognizable subjects — is seemingly an act all can understand, technically and conceptually. Wolfe's art evokes pathos. We cannot take unadulterated delight in his alchemical touch knowing that trompe l'oeil is anachronistic especially given that his works could be — technically speaking — better achieved through high-tech means.

His low-tech, long-term (he has been producing these types of works for three decades) commitment suggests a fierce determination to hold onto something (a sense of humanity?) and to reinvent something that has all but been taken away from us in the electronic age. The books he draws and paints are not new and pristine but show depicted objects that have been possessed, in every sense of the word. They are renderings of book covers of particular subjects, connected personally to the author at particular moments of his life. As Franklin Sirmans writes in this volume, they are not only a self-portrait of the artist but also a portrait of a generation.

They are virtual specimens that have been apprehended and preserved for posterity in an attempt to make permanent what will disappear.

Wolfe's works further propose loss as the culture of the book and the printed word may be on the verge of obsolescence, replaced by inventions such as the Kindle and other portable, paperless reading devices. Thus, *Steve Wolfe on Paper*, the title selected for the exhibition by Wolfe, is not only a double entendre referring to subject and technique, as Foster points out, but it also implies the insistent materiality of his drawings. This obdurate commitment to the material and the handmade in the face of the electronic age is melancholic. Wolfe's works are poised at a crossroads of representation: they are both simulacral surface and referential, associational objects. In discussing the work of Andy Warhol in his seminal essay "The Return of the Real," Hal Foster writes something that can similarly be applied to Wolfe: "And neither projection is wrong. I find them equally persuasive. But they cannot both be right…or can they? Can we read…images as referential and simulacral, connected and disconnected, affective and affectless, critical and complacent?"[2]

Given that Wolfe's work is created in the context of appropriated art, it is not surprising that book covers have served as the primary subject of his art. The designs of the book covers Wolfe has chosen, many from the 1960s and 1970s, offer encyclopedic references to the entire history of art and visual culture. Book designers of this period borrowed indiscriminately, cutting, pasting, modifying, manipulating, and superimposing images and type to create striking covers that would attract attention at a glance and stop consumers in their tracks. They were not subject to the self-imposed strictures and conditions set by artists. Book designers were the original "image scavengers" (a phrase used to describe appropriation artists of the 1970s). By copying these covers, Wolfe returns design to art, in effect returning it to art history, thus rendering the covers useless, as Carter Foster points out, turning them into objects of "erotic frustration."

Sometimes, a project like Wolfe's — so straightforward, so consistent, and so long-term — seems simple. Wolfe literally undermines the notion that you can't tell a book by its cover. You do and you must. It's all cover. Its content is the cover. The "story" is the cover or the aggregate of covers in his multiple book works. However, in striving for verisimilitude in such a direct, seemingly truthful manner, Wolfe creates a visual conundrum, which is well summed up by Hal Foster in his discussion of the philosopher Jacques Lacan and his thoughts on trompe l'oeil. "Thus a perfect illusion is not possible, and even if it were possible it would not answer the question of the real, which always remains, behind and beyond, to lure us. This is so because the real cannot be represented; indeed, it is defined as such, as the negative of the symbolic, a missed encounter, a lost object."[3] It is the irreconcilable character of Wolfe's works that makes them objects of endless fascination and objects of anxiety.

———

It is our great pleasure to unite the Menil Collection and the Whitney Museum of American Art in organizing this exhibition. Both of our museums have been dedicated to the exploration of contemporary art in the context of the history of art, the history of culture, and the history of our own collections. We are also committed to presenting the work of deserving, often overlooked contemporary artists so that our understanding of art and its history can be more nuanced and complete. Thus, this exhibition, the first one-person museum exhibition of Steve Wolfe's work, is not only significant for the artist but for our institutions and the field.

Although the Whitney's collection is often noted for its breadth, the museum is equally recognized for its in-depth focus on the works of key American artists. The Whitney made its first commitment to Steve Wolfe in 1992 when it purchased one of the artist's book sculptures; during the course of the 1990s the Whitney continued to add to its collection of Wolfe's work, including two pieces given by the perspicacious collector and great friend to the museum, Dr. Jack E. Chachkes. In addition to these two, Chachkes — a dentist who supported a number of risk-taking artists early in their careers, including Nicole Eisenman, Charles LeDray, Christian Marclay, and Gary Simmons — bequeathed forty-two other works from his collection, making a significant impact on the Whitney's contemporary holdings. Chachkes had a penchant for surrealist-tinged works, often reflecting an offbeat sense of humor. That there are a total of five works by Wolfe in the Whitney's collection is particularly noteworthy given the artist's painstaking work process; in part, it was this realization that generated the idea for *Steve Wolfe on Paper*.

Co-organizing this exhibition has special meaning to the Menil Collection as it provides the opportunity to acknowledge the bequest of David Grainger Whitney (1939–2005), which introduced Wolfe's work into the museum's collection. David Whitney assumed many professional roles during his lifetime, among them curator, art collector, and advisor to pre-eminent collectors of modern art, including his life-long partner, the architect Philip Johnson (1905–2005). He gained renown for his foresight in acquiring works by important contemporary American artists very early in their careers for his own collection. Whitney served as a member of the Menil Board of Trustees from 1997 to 2004, and in 2006 as part of his bequest, the museum acquired forty-five works by artists such as Vija Celmins, Jasper Johns, Brice Marden, Claes Oldenburg, Robert Rauschenberg, Cy Twombly, and Andy Warhol, along with six sculptures by Steve Wolfe.

We are extremely grateful to the artist for his close involvement in this endeavor and we congratulate the curators Carter E. Foster and Franklin Sirmans for thoughtfully and expertly bringing this project to fruition. Support for the catalogue was provided by the Andy Warhol Foundation for the Visual Arts, Roland Augustine and Lawrence Luhring, and Gail and Tony Ganz. At the Whitney, significant support for this exhibition is provided by Marguerite Steed Hoffman. At the Menil Collection this exhibition is generously supported by the Andy Warhol Foundation for the Visual Arts, Scott and Judy Nyquist, and the City of Houston.

1. Roland Barthes, *S/Z*, trans. Richard Miller (New York: Hill and Wang, 1974), 55.
2. Hal Foster, "The Return of the Real," in *The Return of the Real: The Avant-Garde at the End of the Century* (Cambridge, Mass., and London: MIT Press, 1996), 130.
3. Ibid, 141.

Adam D. Weinberg
Alice Pratt Brown Director
Whitney Museum of American Art

Josef Helfenstein
Director
The Menil Collection

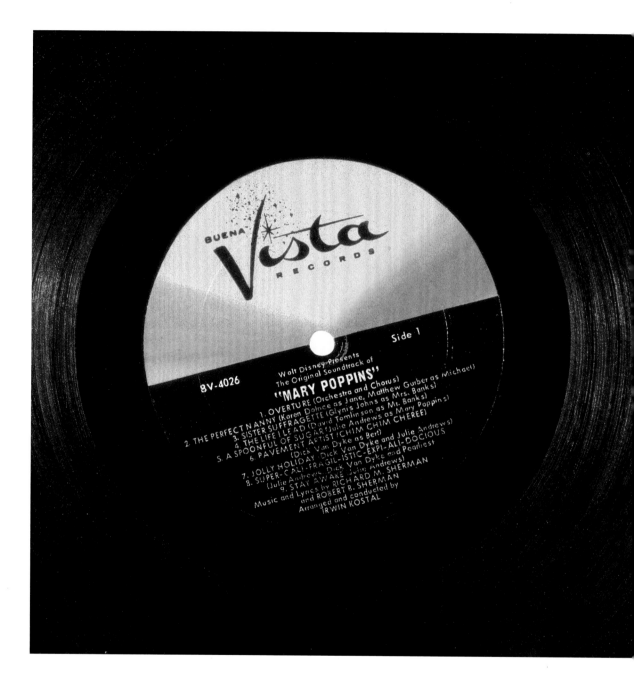

BUENA **Vista** RECORDS

Side 1

BV-4026

Walt Disney Presents
The Original Soundtrack of
"MARY POPPINS"

1. OVERTURE (Orchestra and Chorus)
2. THE PERFECT NANNY (Karen Dotrice as Jane, Matthew Garber as Michael)
3. SISTER SUFFRAGETTE (Glynis Johns as Mrs. Banks)
4. THE LIFE I LEAD (David Tomlinson as Mr. Banks)
5. A SPOONFUL OF SUGAR (Julie Andrews as Mary Poppins)
6. PAVEMENT ARTIST/CHIM CHIM CHEREE)
 (Dick Van Dyke as Bert)
7. JOLLY HOLIDAY (Dick Van Dyke and Julie Andrews)
8. SUPER-CALI-FRAGIL-ISTIC-EXPI-ALI-DOCIOUS
 (Julie Andrews, Dick Van Dyke and Pearlies
9. STAY AWAKE (Julie Andrews)
Music and Lyrics by RICHARD M. SHERMAN
and ROBERT B. SHERMAN
Arranged and conducted by
IRWIN KOSTAL

THE ALCHEMY OF REPRESENTATION

Carter E. Foster

Steve Wolfe (b. 1955) makes trompe-l'oeil objects. That is a simple way to describe his innovative body of sculpture and works on paper. Another description is a modern form of still life. Both genres are important traditions in the history of Western art. Still lifes typically develop meaning through allusion and symbolism and Wolfe's works are no exception, often referring to the history of modernism. More generally, despite their two-dimensionality, still lifes address both the opposition and connection of sight and touch. Still lifes, although artificial, relate profoundly to touch. They have a unique relationship with the viewer because they evoke tactility through representation, and thus address the duality of mind and body. As still lifes, Wolfe's objects similarly evoke the sensation of touch, but they also use memory and its intersection with the physical to address the individual's place within a shared, larger culture.

This catalogue focuses on works on paper, and its title (chosen by the artist) refers to both technique and subject since Wolfe's work often depicts paper in the form of books. His most typical and best-known pieces look like worn paperback books sitting against or set somehow on the wall (fig. 1). As objects in our lives (or at least the lives of active readers), books, though perused individually, are typically *seen* collectively: on shelves, vertically, or in stacks, horizontally, and so the isolation of one single worn volume on a bare wall is one of the artist's important gestures toward the artificial. It sets up these "books" as art objects, while their presence within the context of a gallery or on a wall makes them perusable in a way that is very different from real books.

Although Wolfe is not the only maker of trompe-l'oeil objects in the postwar period, he is its most thorough practitioner. He possesses a virtuoso — indeed almost unbelievable — technical ability to "fool the eye" of the viewer; it is a gift that allows an easy entry to his pieces, though the path down which his objects take the viewer is far more complicated than faithful replication. What initially seems like mere representation is filtered through Wolfe's personal exploration of what representation is; the artist alludes to several art historical precedents, yet the final result is something entirely original.

Traditionally, trompe-l'oeil painting involves the creation of artificial space or the illusion of a material or type of surface. Space itself becomes either expanded or collapsed in some way. Trompe-l'oeil objects, however, have both a simpler and more curious relation to actual space, and they have flourished in the twentieth century, especially in the postwar period. One of the touchstones is Jasper Johns, another postwar artist who explores the idea of trompe-l'oeil both sculpturally and pictorially. His *Painted Bronze* (fig. 2) is a complicated object — a painted

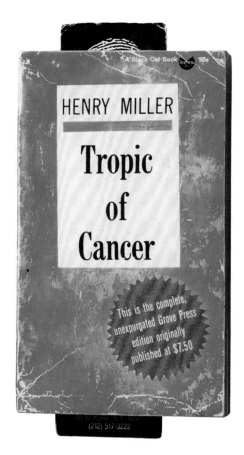

and cast bronze of ordinary studio things: paint brushes and a coffee can to hold them. The very act of turning these common tools into other matter through art processes, and the resulting object itself, allegorize the act of painting: the painter transforms and re-presents the world using his tools and technique; this object is a transformed re-presentation of the painter's basic tools. At a distance, one could easily mistake this object for what it represents; close-up, it is clearly something made. Context is key: in an art gallery or museum it is art, in a hardware store its status would be less clear.

Such objects address thresholds of perception, and they parse such thresholds extremely closely. This is one of the great pleasures of viewing them — the artistic skill they reflect is one quality that makes these works so appealing. How closely has the artist adhered to the original object? Where are the fault lines between the real and the represented? In the history of art this is a basic question, one that often defines the act of looking and the pleasure it gives. The genre of trompe l'oeil concentrates and brings into focus the general pictorial problem of representation and illusionism. This convergence is especially acute in three-dimensional trompe-l'oeil works such as *Painted Bronze* and Wolfe's "books" and "records." Johns has also famously distilled the problem of representation in two dimensions in his *Flag* paintings, which collapse the object with its representation, by asking, how is a painting of a flag different from a flag? In these works, surface and its relation to illusionism and painting becomes crucial — one might even describe the surface as over-determined in such works because it is in the treatment of the surface that all the tension between illusion and reality resides in Johns's paintings. Wolfe's books work in a similar

Figure 1
Untitled (Tropic of Cancer), 1992.
Oil, screenprint, and modeling paste on wood; oil, lithography, and modeling paste on paper,
8 x 4 1/8 x 1 5/16 in. (20.3 x 10.5 x 3.3 cm) overall. Whitney Museum of American Art, New York; Jack E. Chachkes Bequest 95.159a–b

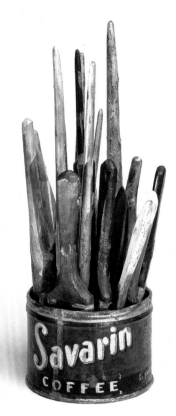

way, except these sculptures (and that is what they technically are) play with this tension even more: Wolfe depicts objects that are themselves an accumulation of surfaces—pages. In real life, the three-dimensionality of books comes from an amassment of two-dimensional sheets of paper. Wolfe's books are objects that correspond one-to-one with actual books, but it is the flat surface of his book covers that carries the representation even as the objects themselves are three-dimensional. The space between representation and reality has become ever thinner, and in Wolfe's objects comes close to merging. In his works on paper, however, Wolfe remains more firmly in the tradition of representation on a flat surface, but because he is depicting something already flat, like Johns's flags, the perceptual nuances are rather narrow.

Seventeenth-century Dutch and late nineteenth-century American trompe-l'oeil still lifes are both relevant precedents here. The latter have significant similarities to Johns's work (fig. 3).[1] The illusion they create of small objects displayed against a flat surface makes for an interesting conceptual space, one parallel to the picture plane, which reveals a reckoning of the importance of flatness, pictorial space, and illusionism in a manner that seems to foreshadow twentieth-century pictorial ideas. But one quality that is particularly evident here is that of touch: in the work of Americans such as John Frederick Peto and John Haberle, what is depicted are *touchable* objects. Similarly, in Dutch still-life paintings artists often emphasized texture and surface in the extreme, and texture and surface quality are what make us want to verify by touch; sight is not enough. This is one of the conundrums that trompe-l'oeil representation and still life: the desire to touch is simultaneously thwarted by the inherent inability to do so.

Figure 2

Jasper Johns (b. 1930), *Painted Bronze*, 1960.

Oil on bronze, 13 1/2 in. (34.3 cm) high, 8 in. (20.3 cm) diameter.

Collection of the artist

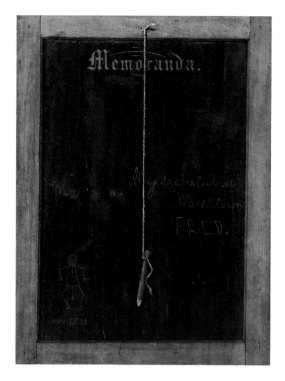

In painting this arises because the things presented are pure illusion; they look like tactile objects, but the pleasure comes from appreciating how well the artist fools the spectator. We can only contemplate touching such an object — feeling it with our imagination — because it is a depiction in paint. Although we are physically capable of touching trompe-l'oeil works, we are not, as spectators, supposed to. If we did, their feel would be different than the feel of what they represent.

One of the points of the types of objects Wolfe chooses as subjects, both books and records, is that they are, in real life, things often touched. They must be thoroughly used in order to be appreciated: one must turn every page of a book and wear every groove of a record. A patina of use develops when these sorts of objects are well appreciated, and in Wolfe's work that patina becomes a musing on the object's importance. But the fact that they are art objects — quite fragile and not meant to be touched — sets up an almost erotic frustration. In the early twentieth century, Marcel Duchamp's readymades set an important precedent. These are familiar objects whose meaning as art derives from context: one sees them displayed in a museum or gallery where they are meant to be interpreted as art and are thus set apart from their ordinary function. Readymades are like instant versions of trompe-l'oeil objects (which also play with meaning through the context of their display), since there is no making involved, no transformation of appearance through material, just a decision to present. Readymades are (or were) familiar objects, so we know what they feel like, but we cannot touch them because they are art — they are meditations on how sight relates to touch and on the frustrations of desire, which is also thwarted touch.

On the other hand, there is a sense of the personal in the objects Wolfe depicts that sets them apart from the readymade. Although books and records are mass-produced, Wolfe makes portraits of *individual* books and records. A series of trompe-l'oeil objects by Vija Celmins

Figure 3
John Haberle (1856–1933), *The Slate: Memoranda*, c. 1895. Oil on canvas, 12 1/8 x 9 1/8 in. (30.8 x 23.2 cm).
Fine Arts Museums of San Francisco; museum purchase by exchange: gift of Miss F. M. Knowles, Mrs. William K. Gutskow,
Miss Keith Wakeman, and the M. H. de Young Endowment Fund

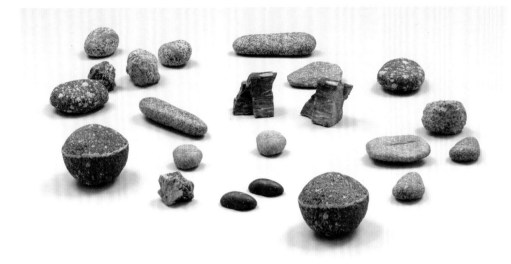

makes an interesting contrast. In making *To Fix the Image in Memory*, Celmins re-created, through casting and painting, a group of found speckled rocks and paired the rocks with their fabricated twins (fig. 4). We marvel at these astonishing objects that entice touch, knowing they would feel cold if we did. But despite their sensorial intrigue, they do not seem to have, or make us want to explore, a connection to a person the way Wolfe's objects do. Robert Gober's newspaper piles (fig. 5), also trompe-l'oeil objects, make another interesting comparison. In contrast to Celmins's rocks and more like Wolfe's books and records, they are cultural and political in their references. Although the work looks like a bound pile of newspapers, Gober substitutes the finest paper and inks for the cheapest, making precious and permanent things out of the disposable. Here are versions of a popular form of cultural detritus (they are formally pristine but are montages, not direct replications). They do not bear evidence of the reader (whose presence is nevertheless implied by the twine tying them together) — these are objects meant to be touched but which seem never to have been. Gober's newspaper piles are unlikely or even impossible in their perfection while Wolfe's objects are warm in their imperfection.

The physical history of Wolfe's objects is one we want to interpret as belonging to the personal history of their owner(s). On the one hand, we might assume (correctly) that the owner is the artist. But worn paperback books and used records are reflections of the culture of their exchange, a culture that thrived in the postwar period although it is now becoming obsolete. In buying or exchanging books and records, the ideas and art they represent far outweigh their importance as physical objects, yet the marks they bear as evidence of previous consumption are an important part of them. As objects with a shared history, their appeal is partly romantic; that they were touched and loved by others is significant. They are the physical manifestation of and pride in intellectual development, a pride shared across time and space. As we now watch them becoming increasingly obsolete, we realize how short a moment in time the thriving

Figure 4
Vija Celmins (b. 1938), *To Fix the Image in Memory*, 1977–82.
Stones and painted bronze, eleven pairs, dimensions variable. The Museum of Modern Art, New York;
gift of Edward R. Broida in honor of David and Renee McKee

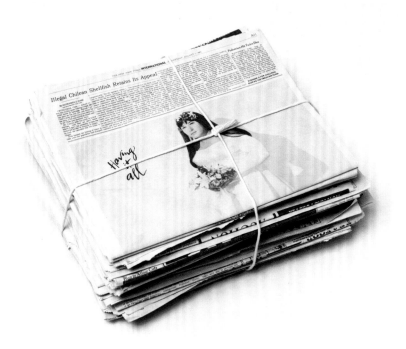

culture of intellectual exchange through these objects really was. The heyday of the paperback book may soon be over; records have essentially disappeared from mainstream culture. The zenith of their pervasiveness in modern life, when the buildup of supply, production, and exchange coalesced most thoroughly, has already passed. Wolfe freezes in time subsets of that era; his familiar personal objects now seem like portraits of artifacts.

The marks, tears, losses, creases, and wear that the artist re-creates on his objects are mundane events turned into the profound. Works of art, intellectual history, and ideas change lives. Our personal copy of Voltaire or Stein represents our own intersection with the greatness of culture. Tears and creases are signs of appreciation, and the accidental, the ordinary, even the negative aspects of wear and age become positive in Wolfe's depictions, things one can associate with profoundly important — potentially life-changing — events, such as the self-discovery that occurs through learning. These marks represent relationships with the object, with the person who created them, and with the work itself and the ideas it represents; the abstract and intangible.

Wolfe's representations of books affixed to walls trigger our memory for touch and may set up a chain of associations that are both physical and psychological depending on what is depicted. His drawings and works on paper, on the other hand, are more formal and often address the history of modernist painting. They do not project into space but almost teasingly play with the exploration of flatness that is so essential to twentieth-century art. In some pieces, the artist takes book covers and splays them out like skinned animals. His drawings of open sketchbooks (pls. 6, 7) address language and art in a Johnsian manner: they depict a tool of the artist's trade using the materials associated with that thing, playing a game of visual metonymy. On the other hand, by presenting them flattened out on the paper that carries their image, one cannot help but read some of their features — the stripe near the binding, the lettering — as

Figure 5

Robert Gober (b. 1954), *Newspaper*, 1992. Photolithographs and twine, approximately 6 x 16 3/4 x 13 1/4 in. (15 x 42.5 x 33.6 cm). Published by the artist; printed by Derrière L'Étoile Studios, New York. The Museum of Modern Art, New York; gift of The Associates in honor of Deborah Wye

references to key moments in modern painting's history: Cubist lettering, collage, and Barnett Newman's zips, for example. In Wolfe's work, technique, subject, and content come together in peculiar ways, sometimes wry and sometimes surprising.

Wolfe's *Untitled (Study for Stories of Artists & Writers)* (pl. 23) re-creates a book cover that is itself a trompe-l'oeil image of a shallow, shadowed space articulated by black and white bars. As in much of his work, the degrees of flatness and illusionism at play here make the reproduction of flatness and illusion not really separate from the actual — all representation in two dimensions can be both illusionistic and flat. The setup is simple and complicated at the same time, profound in the issues of representation it addresses and only possible because of Wolfe's virtuosity with materials. He depicts a flat surface (a book cover that itself has some depth indicated by the creases), which itself has a surface that indicates both flatness and depth. We might see this as a solipsistic essay on the nature of two-dimensional representation and its conundrums. One could compare what the artist does conceptually with "flatness" to what artists in the wake of Abstract Expressionism, such as Johns and Robert Rauschenberg, did with the gestural brushstroke: they put it in quotes in order to comment on it, to make it do other things.

Wolfe's "cartons" are the largest of his pieces, illusions of cheap repurposed cardboard boxes filled with books for which he typically makes fragmented, rectilinear studies. Taking the modernist grid and articulating it with his carefully rendered book covers, Wolfe makes an admirable case, in *Untitled (Study for Eggplant/Gateway 2000 Cartons)* (pl. 28), for one of the basic building blocks of art in the twentieth century. In one fell swoop he shows how the avant-garde gets naturally absorbed into the mainstream, all the while using its formal tools: Piet Mondrian's pristine Neo-Plasticism becomes part of quotidian design as Wolfe juxtaposes a paperback book cover with a reproduction of a Mondrian painting.

We learn and absorb through all manner of conduits. Cheap and simple objects may lead to transformative experiences, and they may further lead to knowledge about objects that represent, in their actuality, the heights of human achievement, such as a painting by a modernist master. But some of this achievement rests in our perception of the thing, not the thing itself, and perception is by and large shaped by the plethora of items and events we see, hold, and use everyday. The intersection of the mundane with the profound is the appealing given behind almost all of Wolfe's work.

1. Roberta Bernstein, "Seeing a Thing Can Sometimes Trigger the Mind to Make Another Thing," in *Jasper Johns: A Retrospective*, ed. Kirk Varnedoe (New York: The Museum of Modern Art, 1996), 56.

THE PRINTED WORD

Franklin Sirmans

"Realism does not lack its partisans, but it does rather conspicuously lack a persuasive theory. And given the nature of our intellectual commerce with works of art, to lack a persuasive theory is to lack something crucial — the means by which our experience of individual works is joined to our understanding of the values they signify." I had gotten it backward all along. Not "seeing is believing," you ninny, but "believing is seeing," for Modern art has become completely literary: the paintings and other works exist only to illustrate the text. —TOM WOLFE[1]

Novelist Tom Wolfe's ironic comment was made in response to a review by former *New York Times* art critic Hilton Kramer of the exhibition *Seven Realists*, held at Yale University Art Gallery in 1974. Quoting Kramer, Wolfe mocks the critic's assertion that Realism lacks the theoretical framework by which an audience might engage with or connect to the experience of art. Kramer's claim and Wolfe's response represent an ongoing debate about realism versus abstraction. Those in the Kramer camp are suspect of the highly honed elements of technique and skill in the hands of the artist, believing that well-crafted representational art is representation for its own sake, without the possibility of meaningful interpretation. Those baffled by abstraction believe that theory with a capital *T* obstructs the ability to enjoy art and that art lacking representational imagery and recognizable content is made for the chosen few who are familiar with or are part of the art establishment. Kramer may no longer think the way he used to,[2] but his earlier views are still held by some. While the debate between the communicative powers of representation versus abstraction continues today, though to a lesser degree, one of its earliest manifestations emerged in the Pop art movement of the late 1950s. In response to the Abstract Expressionism of Willem de Kooning, Barnett Newman, and Jackson Pollack, artists such as Claes Oldenburg, Robert Rauschenberg, and Andy Warhol sought to reclaim personal and cultural representation by reinserting familiar objects or images into their work. New forms of representational art continued to be developed in the 1970s and 1980s by the Photorealists and Neo-Expressionists. Early in his career, artist Steve Wolfe chose a traditional form of representation to depict everyday objects: trompe l'oeil.

While Pop art may be viewed as a rejection of elitism, even as an appeal to popular taste, trompe l'oeil as an artistic device often reflects other intentions. Instead of re-presenting the thing à la Oldenburg's soft sculptures of common objects, Wolfe's work shares more pronounced traits with Warhol's easily recognizable sculptural multiples, like the Brillo boxes made out of wood and the silkscreens of photographs from found mass-media imagery. The

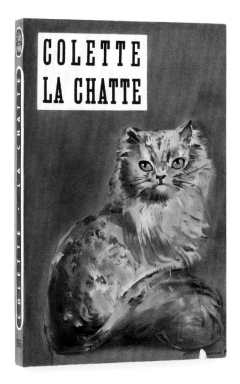

difference here between re-presentation and representation is that trompe l'oeil seeks to depict the subject as it really looks in two or three dimensions, not only as a demonstration of craft and skill but, more importantly, as a tribute to the object and its multivalent meanings.

Known primarily for his mastery of trompe-l'oeil techniques in sculpture and in works on paper, equally important to Wolfe are his subjects: books, and to a lesser degree, records. Personal libraries and record collections tell stories, stories that walk a thin line between perception (what they say about the collector) and intent (what the collector had in mind). "Few possessions are more revealing of their owner's personality, preferences, and self-image than books," said Eleanor Heartney in a 1996 review of Wolfe's work.[3] Or, as Holland Cotter postured in his 2003 review, "Is a personal library a psychological portrait? Sometimes yes, sometimes no."[4]

Taken predominantly from the artist's own collections, Wolfe's books are an archive that reflects not only a self-portrait (they include novels by favorite authors such as Collette, Gustave Flaubert, and Vladimir Nabokov [see fig. 1, pls. 10, 16]), but also a portrait of a generation. From classics of adolescent education, such as Herman Melville's *Moby Dick* (pl. 4), J. D. Salinger's *Nine Stories* (pl. 9), and Jack Kerouac's *On the Road* (fig. 2) to the mature reading of an adult artist, such as Gertrude Stein's *Picasso* (fig. 3), John Cage's *Silence: Lectures and Writings* (pl. 8), and Henry James's *Stories of Artists & Writers* (pl. 23), Wolfe's portrait is drawn broadly and suggests a wide-ranging library of art and ideas, with a nod to what are commonly called "the classics." "Sometimes I find that the titles of some of the books and records I've chosen to add to my 'faux library' (borrowed mostly from my real library) resonate in a way that is autobiographical. Other times, not so much."[5]

But, does it really matter? Juxtapositions can be made or ties can be broken philosophically and aesthetically between the faux and the real. A rendering of Stein's *Picasso* was made

Figure 1
Untitled (La chatte), 1999–2000.
Oil, screenprint, modeling paste, paper, and wood, 6 1/2 x 4 5/16 x 1/2 in. (16.5 x 11 x 1.3 cm).
The Menil Collection, Houston; Bequest of David Whitney

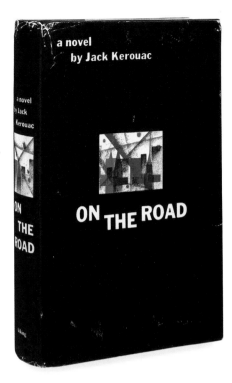

around the same time as Raymond Chandler's *Farewell, My Lovely* (fig. 4). Both evidence an equally worn quality, though with vastly different images. The cover of Chandler's juicy 1940 detective novel (which was produced on film three times) features the tortured grimace of a man having a bed spring slapped across his face, while *Picasso* is represented by an abstracted puzzle of forms. Such a pairing illustrates the elitist-popular art debate by juxtaposing the graphic and the obscure.

Steve Wolfe's music selections are also familiar to many, featuring the sounds of the sixties and seventies. "The Beatles, Bob Dylan, the Velvet Underground, and Joni Mitchell were all major contributors to the soundtrack of my early days." Because Wolfe's albums and singles elicit aural memory as well as visual and verbal, they are, perhaps, even more evocative of a specific moment in time than the books. Generally, the album cover and other packaging have not been the focus of these works; rather, Wolfe recreates the disc — grooves in the vinyl are precisely rendered. The small circular label affixed to the center of the record is the only place for visual individuality, suggesting that the primary focus in these works is the evocation of sound.

"There is no doubt an automatically nostalgic element to my work," Wolfe said recently about his explicitly rendered art, "though it is an element that isn't very interesting to me. I think of nostalgia as a 'hook,' in the same way songwriters sometimes attempt to work 'hooks' into their music in order to grab the listener's attention. It is one way of creating an instantaneous bond with a certain type of viewer, reeling them in for a closer look and engaging them in the kind of reverie that is rare in a world where there is far too much to look at, listen to, and devote one's time to." Believing that nostalgia can often be construed as "cheap," Wolfe hasn't made an image of a record since 2000. "Records have truly become artifacts in the digital age," Wolfe said, and, for that reason, he has left that imagery alone for now.

Like many artists of his generation, Wolfe came to New York in the late 1970s to experience the city and all it had to offer. After a few years of odd jobs, he became a preparator and

Figure 2
Untitled (On the Road), 1995.
Oil, screenprint, modeling paste, paper, canvasboard, and wood, 8 1/4 x 5 7/8 x 1 3/8 in. (21 x 14.9 x 3.5 cm).
The Menil Collection, Houston; Bequest of David Whitney

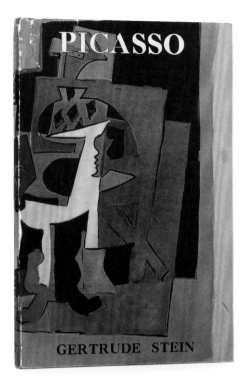

then an archivist at the Paula Cooper Gallery, where he worked off and on for more than six years. Some of the artists being shown there at that time were Donald Judd, Carl Andre, Tony Smith, Jackie Winsor, and Sol LeWitt. While all of them are associated to varying degrees with Minimalism, and they shared an interest in abstract forms and industrial materials, it was the "obsessive fixation" with surface in the work of Judd, Smith, and Winsor that fascinated and influenced Wolfe. In 2006, he exhibited alongside Andre, Judd, LeWitt, and others in a show co-organized by the Fraenkel Gallery in San Francisco and the Peter Freeman Gallery in New York. The exhibition was titled *Nothing and Everything*, defining the seemingly oppositional relationship between the two words.

The preoccupation with surface in Wolfe's work translated into an art form that is as technically meticulous as it is personally illuminating:

> Prior to working on the book sculptures, I was pretty much teaching myself how to draw and paint in a way that I never learned in art school. I wanted to be able to render things realistically, and then hyper-realistically. I drew and painted friends who posed nude, scenes from life inside my saltwater aquarium, photographs of film stills, and objects that were around my work area — an ashtray with cigarette butts, a dirty hand towel and dirty soap. I guess a turning point was when I decided to paint and draw the sketchbook I was drawing in, which had a spiral steel binding and cotton ribbons that enabled the user to tie the sketchbook shut. I did a lot with that image, until finally I made a three-by-four-foot painting of the sketchbook that was verging on being a sculpture in 1986 or 1987, a painting as an object. This enabled me to wonder if I dared try making actual sculpture, even though I was a "painter."

Figure 3

Untitled (Picasso), 1996.
Oil, screenprint, modeling paste, paper, canvasboard, and wood, 8 3/4 x 5 7/8 x 1/2 in. (22.2 x 14.9 x 1.3 cm).
The Menil Collection, Houston; Bequest of David Whitney

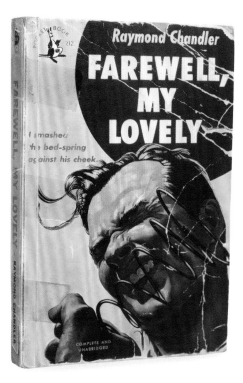

> I found myself making sketches of books open and closed and decided that a sculpture of a book might be far more interesting than a painting of a book, and that a painted sculpture of a book hanging on a wall in the way a painting would, involved some interesting and twisty logic.

While the open-ended nature suggested by an artist's sketchbook provided the conceptual spark for Wolfe, it was the highly personal nature of selecting individual books that brought him to an important breakthrough in his work:

> The first book I decided to replicate was Francis Steegmuller's biography of the poet, filmmaker and artist Jean Cocteau, in 1987. I chose *Cocteau* because I'd always loved the elegant black cover with Cocteau's signature in red scrawled across it. I was thinking of it in terms of the book being a stand-in for the man himself (Jean Cocteau) rather than because I thought the biography was such a great book. The other reason I chose it was because it looked as if it would be fairly easy to replicate, but it wasn't. (The simple-looking images always turn out to be the most difficult, even now.) I began a second piece with an image that appeared to be completely opposite that of *Cocteau*'s in terms of complexity—a Penguin paperback of *Anna Karenina* that I had read on the beach during the summer. The illustration was from a Russian lithograph depicting a snow scene in St. Petersburg circa Tolstoy's time (1828–1910), very complex with lots of images. The book itself was puffed up twice its normal size from being read with wet fingers and from having been exposed to sun and rain for several months.

Figure 4
Untitled (Farewell, My Lovely), 1996.
Oil, screenprint, modeling paste, paper, and wood, 6 3/8 x 4 1/8 x 1/2 in. (16.2 x 10.5 x 1.3 cm).
The Menil Collection, Houston; Bequest of David Whitney

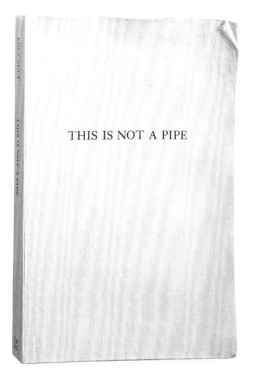

For Wolfe, it is not only the representation of the information the book conveys, but it is the reader's involvement with the object — the wrinkled and cracked covers and the worn and creased pages that is relevant and painstakingly recorded in wood, ink, paper, and paint.

Other early works include two covers for Georges Bataille's literary critique *Literature and Evil* (pl. 3). In 1988–89, Wolfe first depicted the cover of an edition that contained words on a dark background. Shortly thereafter, he created another version, this time using an edition that has a more explicit visual component: a voluptuous, reclining nude. Looking at these two-dimensional studies on paper, it is interesting to see the way the packaging of a book changes with time, or to consider the way we view the images as two-dimensional drawings in comparison with the more emphatic three-dimensional sculptures. (The record albums are also considered two-dimensional, due to their being rendered on rectangular sheets of museum board.)

Untitled (This is Not a Pipe) (fig. 5), a work representing a book whose subject matter resonates with themes in Wolfe's own work, is a trompe-l'oeil version of French philosopher Michel Foucault's study of Surrealist artist René Magritte's series *The Treachery of Images*, in which Magritte explores the relationship between object, text, and image. Surrealism, with its obvious plays on optical reality, is a constant theme throughout Wolfe's work. *Untitled (Nausea)* (fig. 6) reproduces the Penguin paperback version of Jean-Paul Sartre's novel with cover art by Salvador Dalí. It was Sartre's view of literature as "innocent" that inspired Bataille's notion of literature as "evil." Considering any of Wolfe's pieces together creates an engaging dialogue that changes from pairing to pairing.

While working at the Paula Cooper Gallery in the 1980s and perfecting his skills as an artist, Wolfe began to share his work with others. "I knew a lot of people in the art world, which was even smaller than it is now. I slowly invited dealers and other artists to have a look at what I was doing." His first solo show in March of 1989 came about through one such encounter, after

Figure 5
Untitled (This is Not a Pipe), 1987–88.
Oil, enamel, ink transfer, modeling paste, masonite, and wood, 7 5/8 x 5 x 3 3/8 in. (19.4 x 12.7 x 8.6 cm).
The Menil Collection, Houston; Bequest of David Whitney

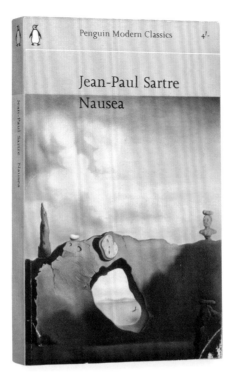

a visit from the young art dealer Diane Brown. In the 1990s Wolfe participated in the exhibitions *Culture in Pieces: Other Social Objects; New Generations: New York*; and *How It Is*, alongside his peers, including Anne Chu, Robert Gober, Suzanne McClelland, and Jack Pierson. Since then Wolfe has had seven more solo exhibitions in galleries and his work has been presented in numerous group exhibitions at museums, including the Menil Collection; the Whitney Museum of American Art; the Hammer Museum in Los Angeles; the Museum of Modern Art, New York; and the San Francisco Museum of Modern Art.

The ephemeral quality of books and records—accentuated in the age of Kindles and iPods—has been replaced in Wolfe's trompe-l'oeil works by a more gradual process of disintegration, that of the artwork to be conserved. Wolfe's visual representations of books and albums, crafted into solid sculptures, conjure the stories and songs that live inside us and ignite memories of experiences that helped shape our identities. These recollections are highly individual and are well preserved by those who are as devoted to their own personal libraries as Wolfe is to his.

1. Tom Wolfe, *The Painted Word* (New York: Bantam, 1975), 6.
2. After working at the *New York Times* from 1965–82, Kramer resigned because he perceived nihilism to be at the heart of new art. In 1983 he cofounded *The New Criterion* with Roger Kimball.
3. Eleanor Heartney, "Steve Wolfe at Luhring Augustine," *Art in America* 84, no. 11 (November 1996), 114.
4. Holland Cotter, "Art in Review; Steve Wolfe," *New York Times*, December 5, 2003.
5. All quotations by Steve Wolfe are from email exchanges with Franklin Sirmans, April–May 2009.

Figure 6
Untitled (Nausea), 1998.
Oil, screenprint, modeling paste, paper, and wood, 7 1/8 x 4 5/8 x 7/8 in. (18.1 x 11.7 x 2.2 cm).
The Menil Collection, Houston; Bequest of David Whitney

PLATES

Note to reader:

← ↑
Arrows in this section indicate the
orientation of works. Unless otherwise
noted, all dimensions indicate image size.
Overall dimensions for each work can
be found on pages 92, 93.

Untitled (Study #2 for Remarks on Colour), 1988 (detail); see plate 1.

Untitled (Study #2 for Remarks on Colour), 1988

Graphite, oil, and screenprint on paper
$8\,^{7}/_{16}$ x $5\,^{3}/_{8}$ in. (21.4 x 13.7 cm)
Collection of Keith Milow

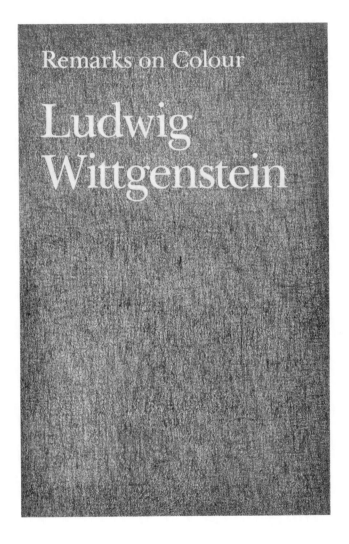

Remarks on Colour

Ludwig Wittgenstein

PLATE 2

Untitled (Study for Cocteau #2), 1989

Graphite, oil, and screenprint on paper
9 $^{7}/_{16}$ x 6 $^{1}/_{2}$ in. (24 x 16.5 cm)
Collection of Barbara Toll

↑

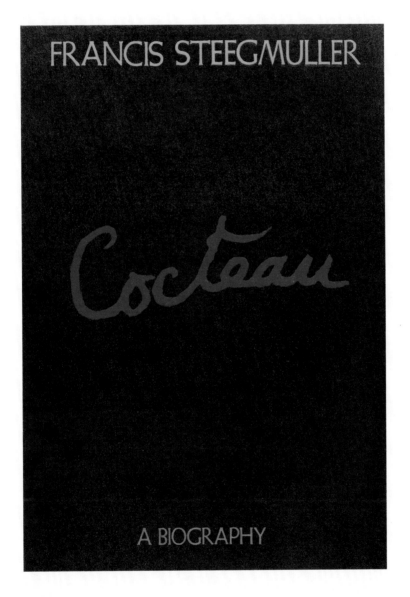

FRANCIS STEEGMULLER

Cocteau

A BIOGRAPHY

PLATE 3

Untitled (Studies for Literature and Evil), 1988

Graphite, oil, and ink transfer on two sheets of paper
7 $^{1}/_{4}$ x 4 $^{1}/_{4}$ in. (18.4 x 10.8 cm) and 8 $^{1}/_{2}$ x 5 $^{1}/_{4}$ in. (21.6 x 13.3 cm)
Collection of Jennifer Bartlett

←

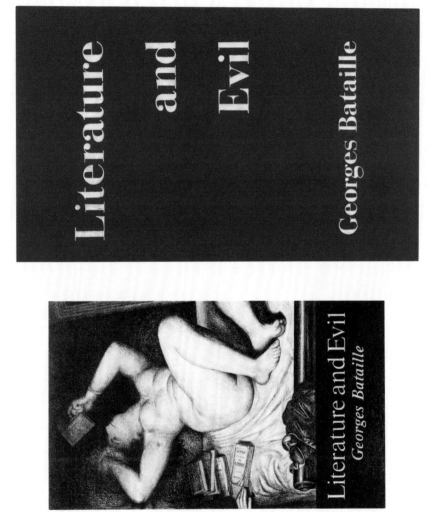

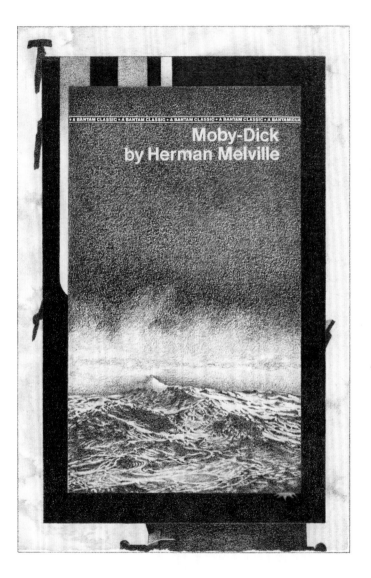

A BANTAM CLASSIC • A BANTAM CLASSIC • A BANTAM CLASSIC • A BANTAM CLASSIC • A BANTAM CLA

Moby-Dick
by Herman Melville

PLATE 5

Untitled (Study for Candide), 1989

Graphite and screenprint on paper
7 $^{1}/_{8}$ x 4 $^{3}/_{8}$ in. (18.1 x 11.1 cm)
Collection of Murray Holman Family Trust

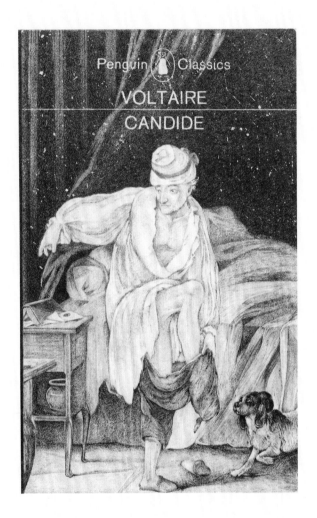

Penguin Classics

VOLTAIRE

CANDIDE

PLATE 7

Untitled (Study for Sketchbook 8F), 1990

Graphite and screenprint on paper
18 ¹/₄ x 30 ⁵/₈ in. (46.4 x 77.8 cm)
Los Angeles County Museum of Art;
Prints and Drawings Acquisition Fund

PLATE 8

Untitled (Study for Silence), 1991

Oil, screenprint, and graphite on board
8 $^{1}/_{4}$ x 6 $^{15}/_{16}$ in. (21 x 17.6 cm)
Collection of Alice Albert

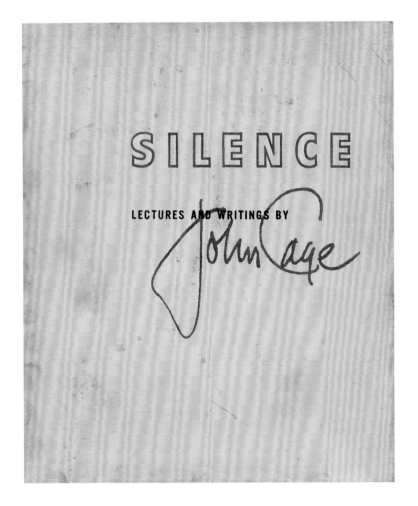

SILENCE

LECTURES AND WRITINGS BY John Cage

PLATE 9

Untitled (Study for Nine Stories), 1992

Oil, screenprint, lithography, and modeling paste on board

7 x 8 3/4 in. (17.8 x 22.2 cm)

Collection of Daniel Weinberg

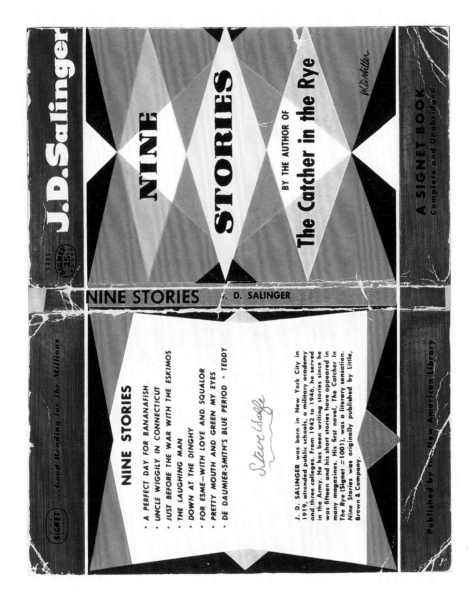

J.D. Salinger

...Good Reading for the Millions

SIGNET
T111
SIGNET
25c

NINE

STORIES

BY THE AUTHOR OF

The Catcher in the Rye

A SIGNET BOOK
Complete and Unabridged

NINE STORIES J. D. SALINGER

NINE STORIES

- A PERFECT DAY FOR BANANAFISH
- UNCLE WIGGILY IN CONNECTICUT
- JUST BEFORE THE WAR WITH THE ESKIMOS
- THE LAUGHING MAN
- DOWN AT THE DINGHY
- FOR ESME—WITH LOVE AND SQUALOR
- PRETTY MOUTH AND GREEN MY EYES
- DE DAUMIER-SMITH'S BLUE PERIOD • TEDDY

J. D. SALINGER was born in New York City in
1919, attended public schools, a military academy
and three colleges. From 1942 to 1946, he served
in the Army. He has been writing stories since he
was fifteen and his short stories have appeared in
many magazines. His first novel, The Catcher in
The Rye (Signet #1001), was a literary sensation.
Nine Stories was originally published by Little,
Brown & Company.

Published by the New American Library

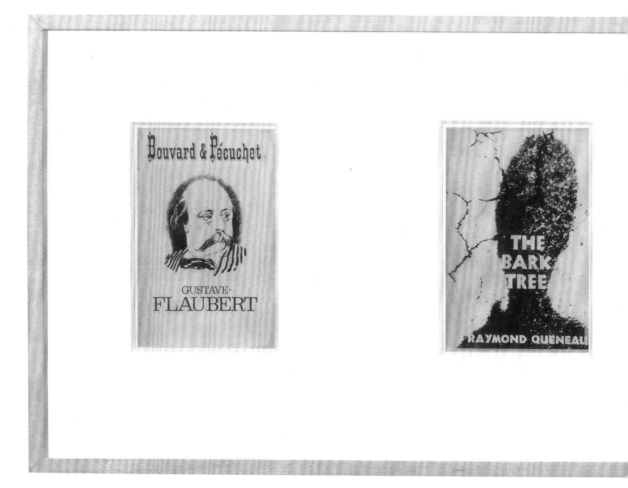

PLATE 10

Untitled (Studies for New Directions), 1992

Oil, lithography, and modeling paste on six boards
14 x 11 3/8 in. (35.6 x 28.9 cm) each
Collection of Beth Barker

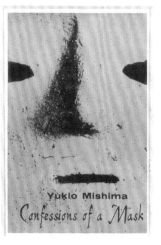

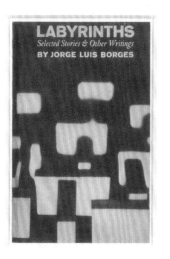

Yukio Mishima
Confessions of a Mask

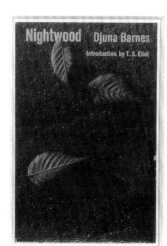

LABYRINTHS
Selected Stories & Other Writings
BY JORGE LUIS BORGES

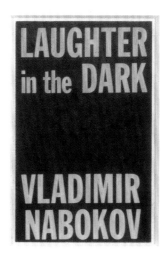

Nightwood Djuna Barnes
Introduction by T. S. Eliot

**LAUGHTER
in the DARK**

**VLADIMIR
NABOKOV**

PLATE 11

Untitled (Do You Believe In Magic?), 1992

Oil, enamel, lithography, and modeling paste on board
7 in. (17.8 cm) diameter
Collection of James and Debbie Burrows

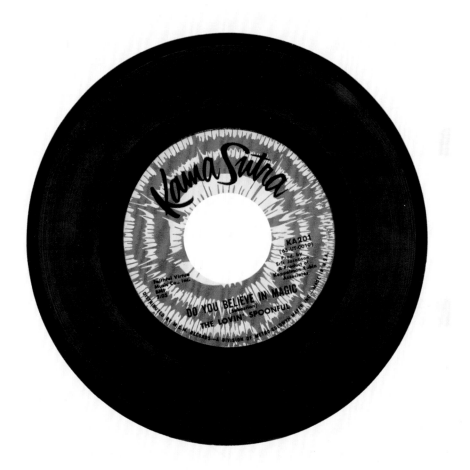

Untitled (Mary Poppins), 1993

Oil, enamel, lithography, and graphite on board
12 in. (30.5 cm) diameter
Private collection

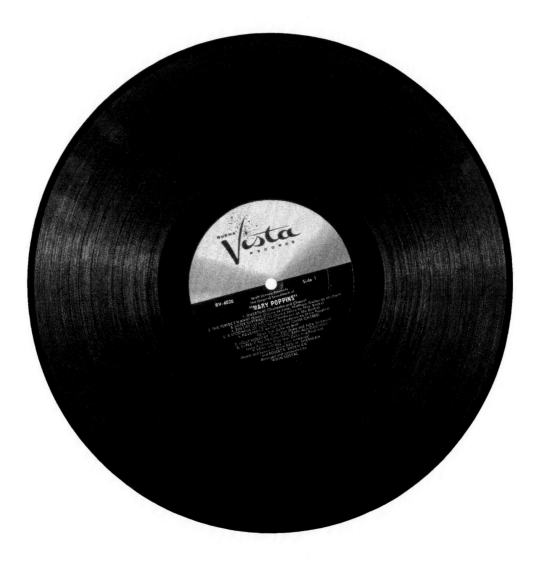

Untitled (Study for Long Island Cheese/Noble Cartons), 1993

Oil, screenprint, lithography, and modeling paste on paper
12 $^{1}/_{2}$ x 18 $^{3}/_{4}$ in. (31.8 x 47.6 cm)
Collection of Daniel Weinberg

MDW

JOSEPH CORNELL

DIANE W. ALDMAN

George Braziller

moonlight

A VINTAGE BOOK V-153 $2.45

3
Lives

The unforgettable stories of three women,
told with poignancy and compassion by one of
the most important writers of our century

Gertrude Stein

9101 GROSSET
& DUNLAP

9102 GROSSET
& DUNLAP

TOM
SWIFT
and His
Flying
Lab

TOM
SWIFT
and His
Jetmarin

VICTOR
APPLETON II

VICTOR
APPLETON II

0
1952

THE CITY AND THE PILLAR

Gore Vidal

CÉLINE
DEATH
ON THE
INSTALLMENT
PLAN

BILLIE HOLIDAY WITH WILLIAM DUFTY **LADY SINGS THE BLUES** ISBN 0 14
00.6162 0

PLATE 14

Untitled (Study for Cutty Sark Carton), 1993

Oil, screenprint, lithography, and modeling paste on paper
$11\,^5\!/\!_8$ x $17\,^7\!/\!_{16}$ in. (29.5 x 44.3 cm)
Collection of Robert Rubin

PLATE 15

Untitled (Study for Chock Full of Nuts/Sinatra/Brown Ale Cartons), 1993

Oil, screenprint, lithography, and modeling paste on paper
16 $^1/_2$ x 9 $^1/_2$ in. (41.9 x 24.1 cm)
Collection of Spero Pastos

The World of Film.

LUIS BUÑUEL

by Ado Kyrou

CHARLOTTE BRONTË
JANE EYRE

The Penguin English Library

PLATE 16

Untitled (Study for Mumm/Jose Cuervo Cartons), 1994

Oil, lithography, screenprint, and modeling paste on paper
11 $^{1}/_{4}$ x 14 $^{3}/_{4}$ in. (28.6 x 37.5 cm)
Collection of Lawrence Luhring

←

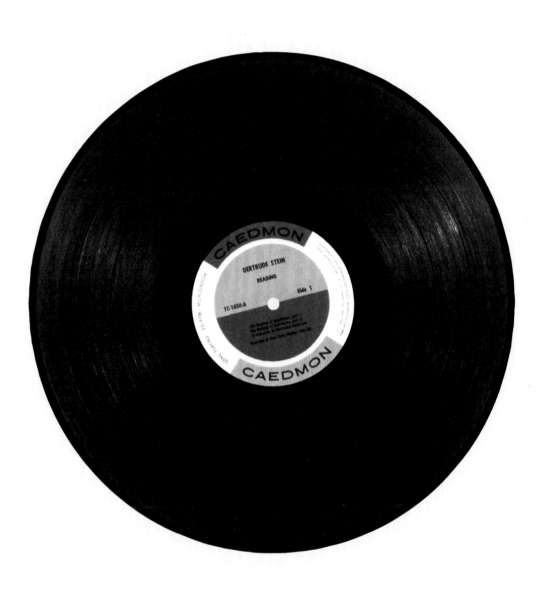

PLATE 18

Untitled (Charlotte's Web), 1994

Oil and screenprint on two boards
17 $^{5}/_{8}$ x 8 $^{5}/_{8}$ in. (44.8 x 21.9 cm) each
Collection of Nancy Reynolds and Dwyer Brown

Untitled (Study for On the Road), 1995

Oil and screenprint on board
8 ¹/₄ x 13 ¹/₈ in. (21 x 33.3 cm)
Collection of Mari and Peter Shaw

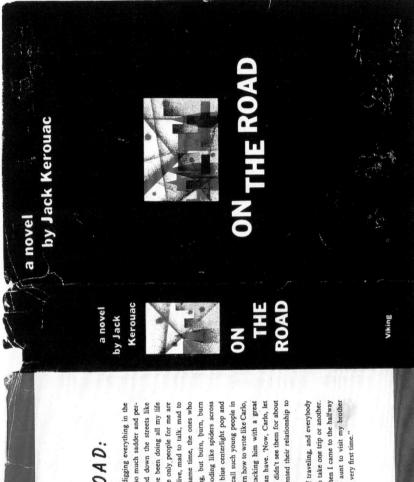

a novel
by Jack Kerouac

ON THE ROAD

a novel
by Jack
Kerouac

ON
THE
ROAD

Viking

FROM *ON THE ROAD:*

"They rushed down the street together, digging everything in the early way they had, which later became so much sadder and perceptive and blank. But then they danced down the streets like dingledodies, and I shambled after as I've been doing all my life after people who interest me, because the only people for me are the mad ones, the ones who are mad to live, mad to talk, mad to be saved, desirous of everything at the same time, the ones who never yawn or say a commonplace thing, but burn, burn, burn like fabulous yellow roman candles exploding like spiders across the stars and in the middle you see the blue centerlight pop and everybody goes 'Awww!' What did they call such young people in Goethe's Germany? Wanting dearly to learn how to write like Carlo, the first thing you know, Dean was attacking him with a great amorous soul such as only a con-man can have. 'Now, Carlo, let *me* speak – here's what *I'm* saying . . .' I didn't see them for about two weeks, during which time they cemented their relationship to fiendish allnight-talk proportions.

"Then came spring, the great time of traveling, and everybody in the scattered gang was getting ready to take one trip or another. I was busily at work on my novel and when I came to the halfway mark, after a trip down South with my aunt to visit my brother Rocco, I got ready to travel West for the very first time."

PLATE 20

Untitled (Study for The City and the Pillar), 1996

Oil, screenprint, and modeling paste on board
8 1/4 x 7 1/4 in. (21 x 18.4 cm)
Collection of Barbara and Peter Benedek

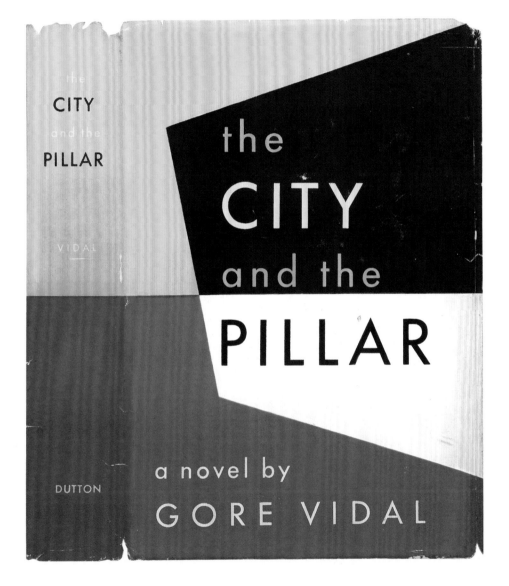

the
CITY
and the
PILLAR

VIDAL

DUTTON

the
CITY
and the
PILLAR

a novel by
GORE VIDAL

Untitled (Study for A Streetcar Named Desire), 1996

Oil, screenprint, and modeling paste on board
9 ¹/₄ x 13 ³/₄ in. (23.5 x 34.9 cm)
Collection of Hilary Miller

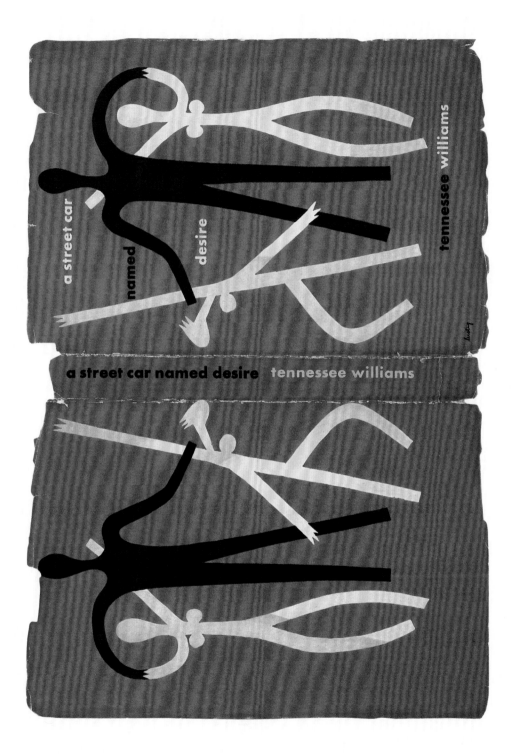

a street car named desire tennessee williams

PLATE 22

Untitled (Study for Picasso), 1996–97

Oil, screenprint, and modeling paste on board
8 5/8 x 11 7/8 in. (21.9 x 30.2 cm)
Collection of Gail and Tony Ganz

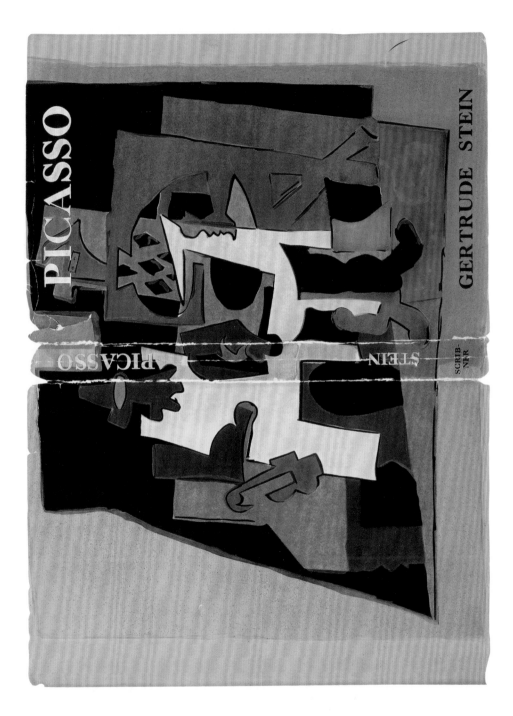

PICASSO

GERTRUDE STEIN

SCRIB-
NER

PLATE 23

Untitled (Study for Stories of Artists & Writers), 1997–98

Graphite and screenprint on paper
7 $^{15}\!/_{16}$ x 5 $^{1}\!/_{2}$ in. (20.2 x 14 cm)
Collection of Gail and Tony Ganz

↑

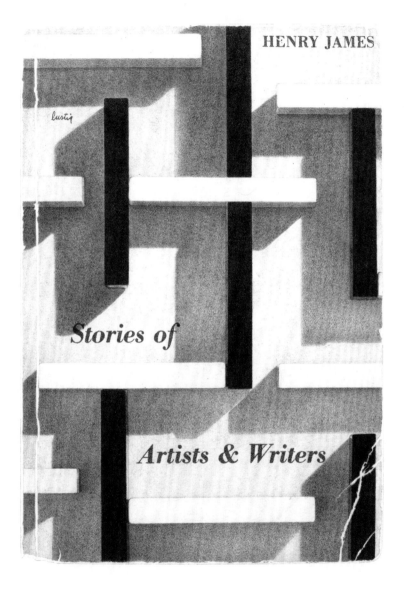

HENRY JAMES

lustig

Stories of

Artists & Writers

PLATE 24

Untitled (Help Me), 1998

Oil, enamel, lithography, and modeling paste on board
7 in. (17.8 cm) diameter
Collection of Carla Emil and Rich Silverstein

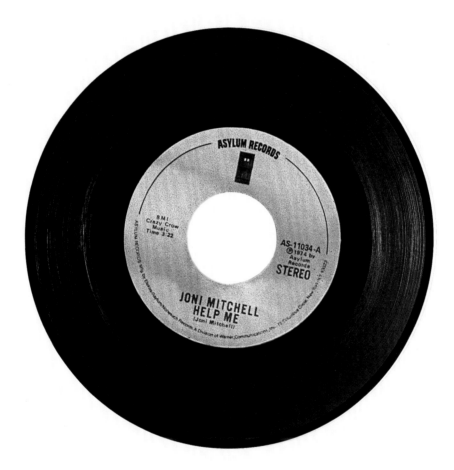

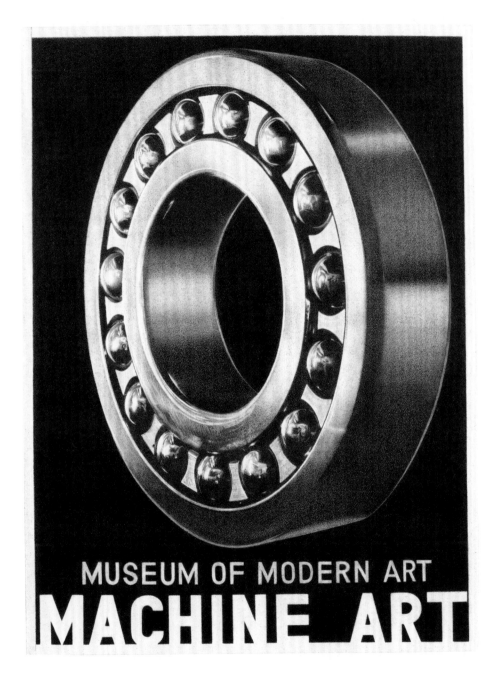

MUSEUM OF MODERN ART
MACHINE ART

PLATE 26

Untitled (Study for Mosquitoes), 1999

Oil, screenprint, modeling paste, and paper mounted on board
6 3/8 x 4 3/4 in. (16.2 x 12.1 cm)
Collection of Gail and Tony Ganz

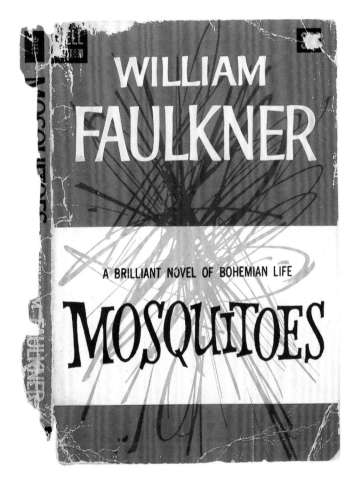

WILLIAM
FAULKNER

A BRILLIANT NOVEL OF BOHEMIAN LIFE

MOSQUITOES

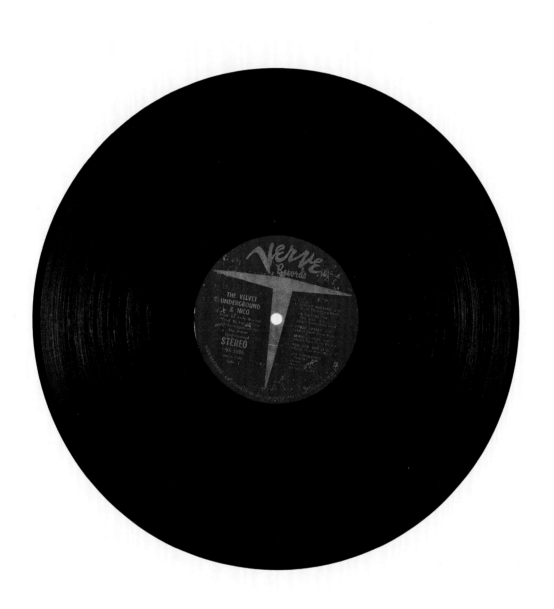

Untitled (Study for Eggplant/Gateway 2000 Cartons), 1996–97

Oil, screenprint, lithography, and modeling paste on two sheets of paper
17 3/8 x 12 1/2 in. (44.1 x 31.8 cm) and 16 7/8 x 12 15/16 in. (42.9 x 40.5 cm)
Whitney Museum of American Art, New York; purchase
with funds from the Drawing Committee 98.10.2a–b

Untitled (Study for Waiting for Godot), 2000

Oil, lithography, ink transfer, modeling paste, and paper on board
$8\,^{1}/_{2}$ x $10\,^{5}/_{8}$ in. (21.6 x 27 cm)
Collection of Gail and Tony Ganz

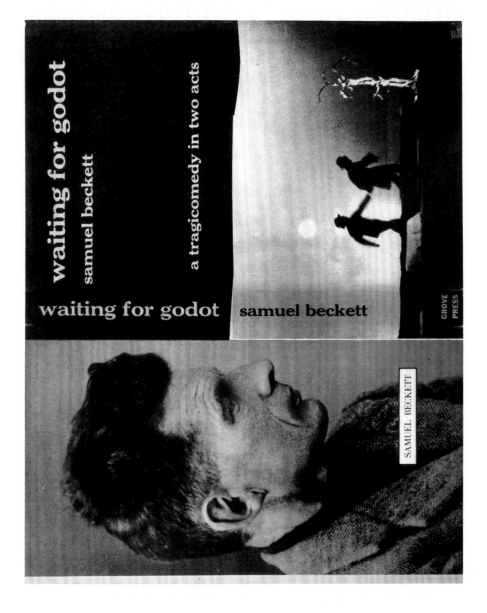

PLATE 30

Untitled (Study for Vanguard/Cooks/Sapporo/Durham's/Campari Cartons), 2003–05

Oil, screenprint, lithography, ink transfer, and modeling paste on paper
12 $^{1}/_{4}$ x 16 $^{3}/_{4}$ in. (31.1 x 42.5 cm)
Courtesy of the artist and Daniel Weinberg Gallery

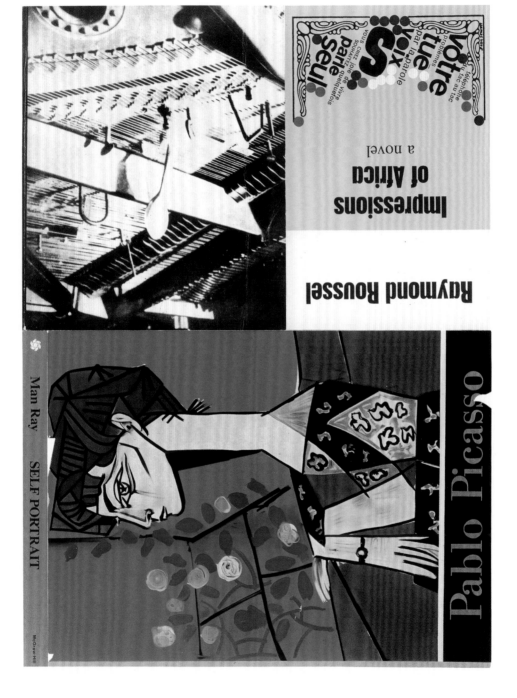

Untitled (Study for the Autobiography of Alice B. Toklas), 2004–05

Oil, lithography, and modeling paste on paper
7 3/4 x 4 5/16 in. (19.7 x 11 cm)
Collection of Joel Wachs

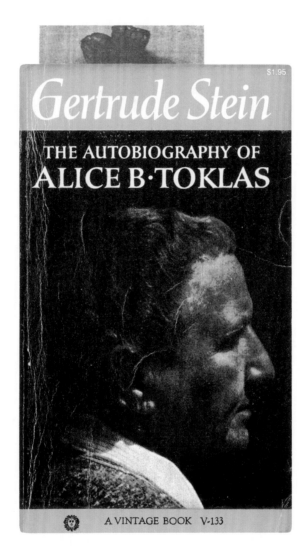

$1.95

Gertrude Stein

THE AUTOBIOGRAPHY OF
ALICE B·TOKLAS

A VINTAGE BOOK V-133

Works in the Exhibition

*For all entries, height precedes width precedes depth. An * indicates that a work is included in the Menil Collection presentation only.*

**Untitled (This is Not a Pipe)*, 1987–88
Oil, enamel, ink transfer, modeling
paste, masonite, and wood
7 5/8 x 5 x 3 3/8 in. (19.4 x 12.7 x 8.6 cm)
The Menil Collection, Houston;
Bequest of David Whitney

Untitled (Studies for Literature and Evil),
1988
Graphite, oil, and ink transfer
on two sheets of paper
16 1/2 x 20 5/8 in. (41.9 x 52.4 cm) framed
Collection of Jennifer Bartlett

Untitled (Study #2 for Remarks on Colour),
1988
Graphite, oil, and screenprint on paper
13 7/16 x 10 7/16 in. (34.1 x 26.5 cm)
Collection of Keith Milow

**Untitled (Study for Cocteau #2)*, 1989
Graphite, oil, and screenprint on paper
13 x 9 3/4 in. (33 x 24.8 cm)
Collection of Barbara Toll

Untitled (Study for Candide), 1989
Graphite and screenprint on paper
10 5/8 x 8 3/4 in. (27 x 22.2 cm)
Collection of Murray Holman
Family Trust

Untitled (Study for Unread Books #1), 1989
Graphite, oil, ink transfer,
and collage on paper
14 3/4 x 12 1/4 in. (37.5 x 31.1 cm)
Collection of Lawrence Luhring

Untitled (Study for Sketchbook 3F), 1990
Graphite and screenprint on paper
22 x 30 in. (55.9 x 76.2 cm)
Private collection

Untitled (Study for Sketchbook 8F), 1990
Graphite and screenprint on paper
30 x 44 in. (76.2 x 111.8 cm)
Los Angeles County Museum of Art;
Print and Drawing Acquisition Fund

Untitled (Study for Silence), 1991
Oil, screenprint, and graphite on board
12 1/8 x 10 3/8 in. (30.8 x 26.4 cm)
Collection of Alice Albert

Untitled (Studies for New Directions), 1992
Oil, lithography, and modeling
paste on six boards
16 3/8 x 70 in. (41.6 x 177.8 cm) framed
Collection of Beth Barker

Untitled (Study for Nine Stories), 1992
Oil, screenprint, lithography,
and modeling paste on board
12 x 13 3/8 in. (30.5 x 34 cm)
Collection of Daniel Weinberg

Untitled (Do You Believe In Magic?), 1992
Oil, enamel, lithography,
and modeling paste on board
9 x 9 in. (22.9 x 22.9 cm)
Collection of James and Debbie Burrows

Untitled (Mary Poppins), 1993
Oil, enamel, lithography, modeling
paste, and graphite on board
16 3/8 x 15 7/8 in. (41.6 x 40.3 cm)
Private collection

*Untitled (Study for Chock Full of Nuts/
Sinatra/Brown Ale Cartons)*, 1993
Oil, screenprint, lithography,
and modeling paste on paper
27 1/2 x 20 1/4 in. (69.9 x 51.4 cm)
Collection of Spero Pastos

Untitled (Study for Cutty Sark Carton), 1993
Oil, screenprint, lithography,
and modeling paste on paper
21 7/16 x 26 13/16 in. (54.5 x 68.1 cm)
Collection of Robert Rubin

*Untitled (Study for Long Island Cheese/
Noble Cartons)*, 1993
Oil, screenprint, lithography,
and modeling paste on paper
24 x 30 in. (61 x 76.2 cm)
Collection of Daniel Weinberg

Untitled (Charlotte's Web), 1994
Oil and screenprint on two boards
17 5/8 x 18 1/4 x 9 1/8 in.
(44.8 x 46.4 x 23.2 cm) framed
Collection of Nancy Reynolds
and Dwyer Brown

*Untitled (Study for Mumm/
Jose Cuervo Cartons)*, 1994
Oil, lithography, screenprint,
and modeling paste on paper
23 5/16 x 26 1/4 in. (59.2 x 66.7 cm)
Collection of Lawrence Luhring

*Untitled (Gertrude Stein Reading,
Side 1)*, 1994
Oil, enamel, lithography,
and modeling paste on board
16 x 14 in. (40.6 x 35.6 cm)
Private collection

**Untitled (On the Road)*, 1995
Oil, screenprint, modeling paste,
paper, canvasboard, and wood
8 1/4 x 5 7/8 x 1 3/8 in. (21 x 14.9 x 3.5 cm)
The Menil Collection, Houston;
Bequest of David Whitney

Untitled (Study for On the Road), 1995
Oil and screenprint on board
15 x 18 3/4 in. (38.1 x 47.6 cm)
Collection of Mari and Peter Shaw

Untitled (Farewell My Lovely), 1996
Oil, screenprint, modeling paste,
paper, and wood
6 $^3/_8$ x 4 $^1/_8$ x $^1/_2$ in. (16.2 x 10.5 x 1.3 cm)
The Menil Collection, Houston;
Bequest of David Whitney

Untitled (Picasso), 1996
Oil, screenprint, modeling paste,
paper, canvasboard, and wood
8 $^3/_4$ x 5 $^7/_8$ x $^1/_2$ in. (22.2 x 14.9 x 1.3 cm)
The Menil Collection, Houston;
Bequest of David Whitney

*Untitled (Study for The City
and the Pillar)*, 1996
Oil, screenprint, and modeling
paste on board
16 x 14 $^1/_4$ in. (40.6 x 36.2 cm)
Collection of Barbara and
Peter Benedek

*Untitled (Study for A Streetcar
Named Desire)*, 1996
Oil, screenprint, and
modeling paste on board
15 $^3/_4$ x 19 $^1/_4$ in. (40 x 48.9 cm)
Collection of Hilary Miller

*Untitled (Study for Eggplant/
Gateway 2000 Cartons)*, 1996–97
Oil, screenprint, lithography, and
modeling paste on two sheets of paper
28 $^{15}/_{16}$ x 51 $^1/_8$ in. (73.5 x 129.9 cm) framed
Whitney Museum of American Art,
New York; purchase with funds
from the Drawing Committee
98.10.2a–b

Untitled (Study for Picasso), 1996–97
Oil, screenprint, and modeling
paste on board
14 x 16 $^3/_4$ in. (35.6 x 42.5 cm)
Collection of Gail and Tony Ganz

*Untitled (Study for Stories of
Artists & Writers)*, 1997–98
Graphite and screenprint on paper
13 x 10 in. (33 x 25.4 cm)
Collection of Gail and Tony Ganz

Untitled (Help Me), 1998
Oil, enamel, lithography, and
modeling paste on board
9 x 9 in. (22.9 x 22.9 cm)
Collection of Carla Emil and
Rich Silverstein

Untitled (Nausea), 1998
Oil, screenprint, modeling paste,
paper, and wood
7 $^1/_8$ x 4 $^5/_8$ x $^7/_8$ in. (18.1 x 11.7 x 2.2 cm)
The Menil Collection, Houston;
Bequest of David Whitney

Untitled (Study for Machine Art), 1998
Graphite and screenprint on paper
13 $^5/_8$ x 10 $^3/_4$ in. (34.6 x 27.3 cm)
Collection of Gail and Tony Ganz

Untitled (Study for Mosquitoes), 1999
Oil, screenprint, modeling paste,
and paper mounted on board
13 x 10 $^3/_4$ in. (33 x 27.3 cm)
Collection of Gail and Tony Ganz

Untitled (La chatte), 1999–2000
Oil, screenprint, modeling paste,
paper, and wood
6 $^1/_2$ x 4 $^5/_{16}$ x $^1/_2$ in. (16.5 x 11 x 1.3 cm)
The Menil Collection, Houston;
Bequest of David Whitney

*Untitled (The Velvet Underground
& Nico, Side 1)*, 1999–2000
Oil, enamel, lithography, and modeling
paste on board
16 x 14 in. (40.6 x 35.6 cm)
Collection of Marguerite and
Robert Hoffman

Untitled (Study for Waiting for Godot), 2000
Oil, lithography, ink transfer, modeling
paste, and paper on board
14 $^1/_2$ x 16 $^1/_4$ in. (36.8 x 41.3 cm)
Collection of Gail and Tony Ganz

*Untitled (Study for Vanguard/Cooks/
Sapporo/Durham's/Campari Cartons)*,
2003–05
Oil, screenprint, lithography, ink
transfer, and modeling paste on paper
21 $^1/_2$ x 25 $^3/_4$ in. (54.6 x 65.4 cm)
Courtesy of the artist
and Daniel Weinberg Gallery

*Untitled (Study for the Autobiography
of Alice B. Toklas)*, 2004–05
Oil, lithography, and modeling
paste on paper
14 $^3/_4$ x 10 $^3/_4$ in. (37.5 x 27.3 cm)
Collection of Joel Wachs

As of July 10, 2009

Selected Exhibition History

Born 1955, Pisa, Italy
Lives and works in San Francisco

EDUCATION

BA, Virginia Commonwealth
University, Richmond, 1977

AWARDS

2000

Academy Award, American Academy
of Arts and Letters, New York

SELECTED SOLO EXHIBITIONS

2003

Luhring Augustine, New York
(catalogue)

1996

Luhring Augustine, New York,
Works on Paper

1994

Daniel Weinberg Gallery, San Francisco,
Works on Paper

1993

Luhring Augustine, New York,
2 Recent Works

1992

Daniel Weinberg Gallery, Santa Monica,
California

1990

Diane Brown Gallery, New York

1989

Diane Brown Gallery, New York

SELECTED GROUP EXHIBITIONS

2009

San Francisco Museum of Modern Art,
*Between Art and Life: The Contemporary
Painting and Sculpture Collection*

2008

The FLAG Art Foundation, New York,
Attention to Detail (catalogue)

The Israel Museum, Jerusalem,
Bizarre Perfection

The Museum of Modern Art, New York,
Book/Shelf

San Francisco Museum of Modern Art,
*Passageworks: Contemporary Art from
the Collection*

2007

Hammer Museum, University of
California, Los Angeles, *Hammer
Contemporary Collection: Part II*

Collezione Maramotti, Reggio Emilia,
Italy, inaugural exhibition

The Menil Collection, Houston, Texas,
The David Whitney Bequest

Whitney Museum of American Art,
New York, *2D –> 3D*

2006

Peter Freeman Inc., New York, *Nothing
and Everything* (catalogue); traveled to
Fraenkel Gallery, San Francisco

The Frances Young Tang Teaching
Museum at Skidmore College, Saratoga
Springs, New York, *Twice Drawn*

Whitney Museum of American Art,
New York, *Full House: Views of the
Whitney's Collection at 75*

Whitney Museum of American Art,
New York (organizer), *Extra–Ordinary:
Selections from the Permanent
Collection of the Whitney Museum of
American Art*; traveled to New York
State Museum, Albany (2005, brochure);
Frist Center for the Visual Arts,
Nashville, Tennessee; Austin Museum
of Art–Downtown, Texas (Wolfe not
included in initial venue)

2005

Daniel Weinberg Gallery, Los Angeles,
*On Paper: Drawings from the 1960s
to the Present*

2003

Fraenkel Gallery, San Francisco,
Not Exactly Photographs

New York State Museum, Albany,
*Strangely Familiar: Approaches to Scale
in the Collection of The Museum
of Modern Art, New York* (brochure)

2000

American Academy of Arts and Letters,
New York, *American Academy
Invitational Exhibition of Painting
and Sculpture*

Luhring Augustine, New York,
Untitled (Sculpture)

The Museum of Modern Art, New York,
Open Ends: Actual Size

San Francisco Museum of Art,
*Fact/Fiction: Contemporary Art That
Walks the Line*

1999

The Drawing Center, New York,
Drawn From Artists' Collections
(catalogue); traveled to Hammer
Museum, University of California,
Los Angeles

1998

Fraenkel Gallery, San Francisco, *Dust Breeding: Photographs, Sculpture & Film*, curated by Steve Wolfe (catalogue)

The Museum of Modern Art, New York, *More Pieces for the Puzzle: Recent Additions to the Collection*

1997

San Francisco Museum of Modern Art, *Present Tense: Nine Artists in the Nineties* (catalogue)

1996

Luhring Augustine, New York, *Exposure*

1995

Berkeley Art Museum, University of California, *In a Different Light*

Exhibition Management Inc., Cleveland (organizer), *It's Only Rock and Roll: Rock and Roll Currents in Contemporary Art* (catalogue); traveled to Contemporary Arts Center, Cincinnati, Ohio; Lakeview Museum of Arts and Sciences, Peoria, Illinois; Virginia Beach Center for the Arts; Tacoma Art Museum, Washington; Jacksonville Museum of Contemporary Art, Florida; Dean Lesher Regional Center for the Arts, Walnut Creek, California; Phoenix Art Museum, Arizona; Lowe Art Museum, Coral Gables, Florida; Milwaukee Art Museum, Wisconsin; Arkansas Art Center, Little Rock

Fisher Landau Center for Art, Long Island City, New York, *Articulations: Forms of Language in Contemporary Art*, curated by students of the Whitney Museum of American Art Independent Study Program (catalogue)

Daniel Weinberg Gallery, San Francisco, *Artschwager, Cain, Celmins, Close, Cornell, Gober, Stoll, Wolfe* (organized by Steve Wolfe and Daniel Weinberg)

1994

Luhring Augustine, New York, *Sculpture*

1993

Russisches Kulturzentrum, Berlin, Germany, *Extravagant: The Economy of Elegance*

Daniel Weinberg Gallery, Santa Monica, California, *Twenty Years: A Series of Anniversary Exhibitions, Part II*

1992

Fisher Landau Center for Art, Long Island City, New York, *Material Matters: Photography and Sculpture from the Collection*

Tony Shafrazi Gallery, New York, *How It Is*

1991

Carnegie Mellon Art Gallery, Pittsburgh, Pennsylvania, *New Generations: New York* (catalogue)

Jay Gorney Modern Art, New York, *Michael Landy, Christian Marclay, Peter Nagy, Andreas Schon, Steve Wolfe*

Hallwalls Contemporary Arts Center, Buffalo, New York, *The Library of Babel: Books to Infinity* (catalogue); traveled to White Columns, New York

Lorence–Monk Gallery, New York, *Artists' Books*

Robert and Elain Stein Galleries, Wright State University (formerly Museum of Contemporary Art at Wright State University), Dayton, Ohio, *Words & #s* (catalogue)

1990

Beaver College Art Gallery, Glenside, Pennsylvania, *Culture in Pieces: Other Social Objects* (catalogue)

Laurie Rubin Gallery, New York, *Ron Baron, Christian Marclay, Steve Wolfe*

1989

Barbara Toll Fine Art, New York, *A Good Read: The Book as a Metaphor*

Selected Bibliography

Alden, Todd, and Paul Hodengräber. *The Library of Babel*. Exhibition catalogue. Buffalo: Hallwalls Contemporary Arts Center, 1991.

Anderson, Maxwell L., et al. *American Visionaries: Selections from the Whitney Museum of American Art*. New York: Whitney Museum of American Art, 2001.

Bonetti, David. "Weinberg Gallery Shows How It's Done." *San Francisco Examiner*, April, 6, 1995.

Bonetti, David. "Out of the Past: Portraits of the Artists." *San Francisco Examiner*, September 2, 1997.

Camhi, Leslie. "An Artist's Library Lovingly, Painstakingly Reproduced." *Village Voice*, December 3–9, 2003, 87.

Cole, Lori. "Nothing and Everything." *Artforum.com*, October 17, 2006, artforum.com/archive/id=11899.

Cotter, Holland. "Art in Review; Steve Wolfe." *New York Times*, December 5, 2003.

De Corral, Maria, and John R. Lane. *Fast Forward: Contemporary Collections for the Dallas Museum of Art*. Exhibition catalogue. New Haven: Yale University Press, 2007.

Fraenkel, Jeffrey, and Peter Freeman, eds. *Nothing and Everything*. Exhibition catalogue. San Francisco: Fraenkel Gallery; New York: Peter Freeman, 2006.

Frankel, David. "Steve Wolfe." *Artforum* 42, no. 5 (January 2004): 153.

Heartney, Eleanor. "Steve Wolfe at Luhring Augustine." *Art in America* 84, no. 11 (November 1996): 114–15.

Helfand, Glen. "Selective Service." *San Francisco Weekly*, July 6, 1994.

The Museum of Modern Art. *MoMA Highlights: 350 Works from The Museum of Modern Art, New York*. New York: The Museum of Modern Art, 2004.

San Francisco Museum of Modern Art. *Present Tense: Nine Artists in the Nineties*. Exhibition catalogue. San Francisco: San Francisco Museum of Modern Art, 1997.

Jana, Reena. "How It Was Done: An Artist Painstakingly Re-creates Books from His Own Library" *Art on Paper* 10, no. 3 (January/February 2006): 33–34.

Johnson, Ken. "Steve Wolfe at Diane Brown." *Art in America* 77, no. 9 (September 1989): 204–5.

Mahoney, Robert. "Steve Wolfe at Luhring Augustine." *Artnet Magazine*, March 22, 1996, artnet.com/ magazine_pre2000/reviews/ mahoney/mahoney1.asp.

Newhall, Edith. "Steve Wolfe." *ArtNews* 90, no. 1 (January 1991): 150–51.

Rubin, David. *It's Only Rock and Roll: Rock and Roll Currents in Contemporary Art*. Exhibition catalogue. Munich: Prestel Publishing, 1995.

Smith, Roberta. "Steve Wolfe." *New York Times*, Friday, March 31, 1989.

Tone, Lilian. "Dimensions of the Real." *MoMA* (October 2000): 6–9.

Weatherspoon Art Gallery. *Thirty-Third Annual Exhibition of Art on Paper: November 16, 1997–January 18, 1998, Weatherspoon Art Gallery, University of North Carolina at Greensboro*. Exhibition catalogue. Greensboro: The University of North Carolina, 1997.

Westfall, Stephen. "Steve Wolfe at Luhring Augustine." *Art in America* 92, no. 4 (April 2004): 125.

White, Edmund. *Steve Wolfe*. Exhibition catalogue. New York: Luhring Augustine, 2003.

Wilson, Michael. "Steve Wolfe." *Frieze* 81 (March 2004): 110.

Wolfe, Steve. *Dust Breeding: Photographs, Sculpture and Film*. Exhibition catalogue. San Francisco: Fraenkel Gallery, 1998.

Yablonsky, Linda. "Faux World: Two New Shows in Chelsea Fake It For Real." *Time Out New York*, November 27, 2003, 80–81.

Acknowledgments

Steve Wolfe's poetic and evocative body of work inspires unusual devotion among those who have collected and appreciated his art over the years. It has been a pleasure to develop this project with him, and we gratefully acknowledge his caring attention to both the exhibition and catalogue. We are thrilled to have had the generous help of friends and colleagues who supported this first museum presentation of Wolfe's work in significant ways.

First and foremost, we heartily thank the institutional and individual lenders for their willingness to temporarily part with works from their collections. We also extend our deep gratitude to Roland Augustine and Lawrence Luhring of Luhring Augustine, and their West Coast director Vanessa Critchell, all of whom devoted invaluable time and resources; they were ably assisted by Caroline Burghardt and Tiffany Edwards. We also thank Daniel Weinberg and the staff at his gallery in Los Angeles, particularly Megan Dudley.

At the Whitney Museum of American Art, we graciously acknowledge the guidance and enthusiasm of Adam D. Weinberg, Alice Pratt Brown Director, and Donna De Salvo, chief curator and associate director for programs, as well as the support of the board of trustees under the leadership of Robert J. Hurst and Brooke Garber Neidich. The project depended on the hard work of the Whitney's curatorial and exhibitions team, and we thank curatorial assistant Kristin Sarli; exhibitions manager Maura Heffner; associate registrar Emilie Sullivan; manager of design and construction Mark Steigelman; associate director of exhibitions and collection management Christy Putnam; and senior curatorial assistant Tina Kukielski. We would also like to express our appreciation for the fundraising efforts of major gifts officer Mary Anne Talotta and director of foundations and government relations Hillary Strong.

At the Menil Collection, we gratefully acknowledge director Josef Helfenstein's continued vision and counsel and recognize the enthusiastic support for this exhibition shown by the board of trustees and its president, Harry Pinson, as well as its chairman, Louisa Stude Sarofim. Their dedication was matched by the museum's staff. Assistant curator Michelle White and curatorial interns Rachel Greene and Angela Bankhead provided valuable insight and research. We are sincerely grateful to publisher Laureen Schipsi who edited Franklin's text, aided by Laura Fletcher. As always, the entire curatorial department was instrumental in bringing this project to fruition: Bernice Rose, chief curator of the Menil Drawing Institute and Study Center; associate curator for collections and research Kristina Van Dyke; curatorial assistant Mary Lambrakos; curatorial coordinator Melanie Crader; and curatorial administrative assistant Ryan Dennis. We are also indebted to the staff in the many departments at the Menil Collection who helped to make this exhibition a reality.

The catalogue was produced by the Whitney's publication department in association with the Menil Collection, and we thank Rachel de W. Wixom, head of publications, and associate editor Beth Turk. Jay Stewart of Capital Offset handled the color proofing with great consideration and skill. Mark Nelson, Michelle Nix, and Yeonjae Yuk of McCall Associates developed the beautiful design, working thoughtfully and patiently with artist, authors, and editor alike.

Carter E. Foster
Curator of Drawings
Whitney Museum of American Art, New York

Franklin Sirmans
Curator of Modern and Contemporary Art
The Menil Collection, Houston

Lenders to the Exhibition

Alice Albert
Beth Barker
Jennifer Bartlett
Barbara and Peter Benedek
James and Debbie Burrows
Carla Emil and Rich Silverstein
Gail and Tony Ganz
Marguerite and Robert Hoffman
Murray Holman Family Trust
Los Angeles County Museum of Art
Lawrence Luhring
The Menil Collection, Houston
Hilary Miller
Keith Milow
Spero Pastos
Nancy Reynolds and Dwyer Brown
Robert Rubin
Mari and Peter Shaw
Barbara Toll
Joel Wachs
Daniel Weinberg
Whitney Museum of American Art, New York
Steve Wolfe and Daniel Weinberg Gallery

Private collections

Whitney Museum of American Art Staff

100

The Menil Collection Staff

Anne C. Adams
John C. Akin
Geraldine Aramanda
Patrice A. Ashley
Adam R. Baker
Oliver Mathais Bakke III
Lisa Barkley
Jocelyn Elaine Bazile
Tobin B. Becker
Peter D. Bernal
Melissa M. Brown
Delana A. Bunch
Janice Burandt
Sabina Causevic
Erh-Chun A. Chien
Peter Cohen
Margaret Elsian Cozens
Melanie Crader
William Cuevas
Lisa M. Delatte
Ryan Dennis
Kenneth S. Dorn
Brenda G. Durden
Clare S. Elliott
Ralph W. Ellis
Bradford A. Epley
Susan Epley
Ernest Flores
Marta Galicki
Latisha S. Gilbert
Earline Gray
J. D. Griffin
Barbara Grifno
Vera Hadzic
Ellen Hanspach
Judith M. Hastings
Dawn Hawley
Katherine R. Heinlein
Josef Helfenstein
Jennifer Hennessy
Shawnie E. Hunt
Alem Z. Imru
Mary L. Kadish
Karl Kilian
Shablis Kinsella
Susan Kmetz
Judy M. Kwon
Brian LaFleur
Mary Lambrakos
Guillermo S. Leguizamon
Shiow-Chyn Liao
Thomas J. Madonna
Suzanne M. Maloch
Rita Marsales

Anthony Martinez
Sylvester Martinez
Steve A. McConathy
Ebony McFarland
Sharon Elaine McGaughey
Erma J. McWell
Getachew Mengesha
Vance Muse III
Mohammed Osman
Adriana Perez
Patrick J. Phipps
Timothy Quaite
Lajeanta A. Rideaux
Laura E. Rivers
Sandra S. Rodriguez
Bernice B. Rose
Antonio Rubio
Laureen R. Schipsi
Kristin K. Schwartz-Lauster
Irvin K. Semiens
M. Franklin Sirmans
Mirzama Sisic
Roy A. Skorupinski
Thelma M. Smith
Brooke M. Stroud
Konjit T. Tekletsadik
Emily Todd
Maurice Truesdale
Kristina M. Van Dyke
Thomas F. Walsh
Timothy D. Ware
Michelle White
Aline Wilson

As of July 10, 2009

This catalogue was published on the occasion of the exhibition *Steve Wolfe on Paper*, organized by Carter E. Foster, curator of drawings, with the assistance of Kristin Sarli, curatorial assistant, Whitney Museum of American Art, New York, and by Franklin Sirmans, curator of modern and contemporary art, the Menil Collection, Houston.

Whitney Museum of American Art, New York
September 30–November 29, 2009

The Menil Collection, Houston
April 2–October 31, 2010

Support for this catalogue was provided by The Andy Warhol Foundation for the Visual Arts, Roland Augustine and Lawrence Luhring, and Gail and Tony Ganz.

In New York, significant support for this exhibition is provided by Marguerite Steed Hoffman.

In Houston, this exhibition is generously supported by The Andy Warhol Foundation for the Visual Arts, Scott and Judy Nyquist, and the City of Houston.

WHITNEY

Whitney Museum of American Art
945 Madison Avenue
New York, NY 10021
whitney.org

THE MENIL COLLECTION

The Menil Collection
1515 Sul Ross Street
Houston, TX 77006
menil.org

Library of Congress Cataloging-in-Publication Data

Foster, Carter E.
 Steve Wolfe on paper / Carter E. Foster, Franklin Sirmans.
 p. cm.
 Published on the occasion of an exhibition held at the Whitney Museum of American Art, New York, N.Y., Sept. 30–Nov. 29, 2009 and at the Menil Collection, Houston, Tex., Apr. 2–Oct. 31, 2010.
 Includes bibliographical references.
 ISBN 978-0-300-15898-4
 1. Wolfe, Steve, 1955——Exhibitions. I. Wolfe, Steve, 1955– II. Sirmans, Franklin. III. Whitney Museum of American Art. IV. Menil Collection (Houston, Tex.) V. Title.
 NC139.W645A4 2009
 760.092——DC22

 2009020174

Distributed by
Yale University Press
302 Temple Street, P.O. Box 209040
New Haven, CT 06520-9040
yalebooks.com

Printed and bound in USA
10 9 8 7 6 5 4 3 2 1

This publication was produced by the Publications Department of the Whitney Museum of American Art, New York: Rachel de W. Wixom, head of publications; Beth A. Huseman, editor; Beth Turk, associate editor; Anita Duquette, manager, rights and reproductions; Kiowa Hammons, rights and reproductions assistant; in association with the Publications Department at the Menil Collection, Houston: Laureen Schipsi, publisher.

Editor: Beth Turk
Catalogue design: McCall Associates with Steve Wolfe
Typeset in Kepler and Kievit; printed on 148gsm Sappi Lustro
Printing: Capital Offset, Concord, NH

Photograph and reproduction credits
All images of work by Steve Wolfe are © 2009 Steve Wolfe and appear courtesy the artist, Luhring Augustine, New York, and Daniel Weinberg Gallery, Los Angeles.
The following applies to photographs for which additional acknowledgment is due (italic numerals indicate page numbers):
13 Art © Jasper Johns/Licensed by VAGA, New York, NY.
15 © Vija Celmins; digital image © The Museum of Modern Art / Licensed by SCALA/Art Resource, NY. *16* © Robert Gober; digital image © The Museum of Modern Art/Licensed by SCALA/ Art Resource, NY. *29, 31, 33, 37, 43, 77* Photograph by Farzad Owrang Photography. *45, 51* Photograph by Anthony Cunha.